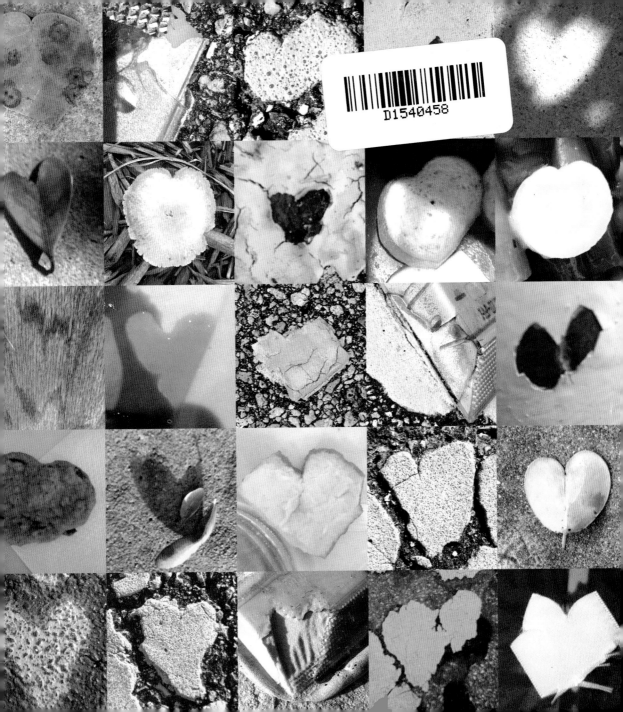

For my parents, Stephen and Barbara.
Thank you for making me.

DIAL BOOKS FOR YOUNG READERS · a division of Penguin Young Readers Group · Published by The Penguin Group Penguin Group (USA) Inc., 375 Hudson Street, New York, NY 10014, U.S.A. · Penguin Group (Canada), 90 Eglinton Avenue East, Suite 700, Toronto, Ontario, Canada M4P 2Y3 (a division of Pearson Penguin Canada Inc.) · Penguin Books Ltd, 80 Strand, London WC2R 0RL, England · Penguin Ireland, 25 St. Stephen's Green, Dublin 2, Ireland (a division of Penguin Books Ltd) · Penguin Group (Australia), 250 Camberwell Road, Camberwell, Victoria 3124, Australia (a division of Pearson Australia Group Pty Ltd) · Penguin Books India Pvt Ltd, 11 Community Centre, Panchsheel Park, New Delhi - 110 017, India · Penguin Group (NZ), 67 Apollo Drive, Rosedale, Auckland 0632, New Zealand (a division of Pearson New Zealand Ltd) · Penguin Books (South Africa) (Pty) Ltd, 24 Sturdee Avenue, Rosebank, Johannesburg 2196, South Africa · Penguin Books Ltd, Registered Offices: 80 Strand, London WC2R 0RL, England · Copyright © 2012 by Eric Telchin · All rights reserved · The publisher does not have any control over and does not assume any responsibility for author or third-party wesites or their content. · Designed by Jasmin Rubero and Eric Telchin · Text set in Sassoon Infant Com · Manufactured in China on acid-free paper · Library of Congress Cataloging-in-Publication Data is available · 10 9 8 7 6 5 4 3 2 1

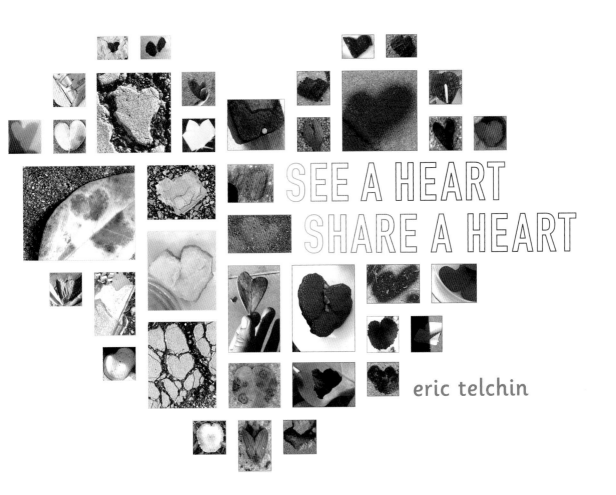

SEE A HEART
SHARE A HEART

eric telchin

Dial Books an imprint of Penguin Group (USA) Inc.

See a heart

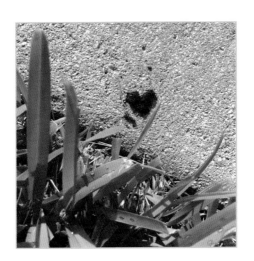

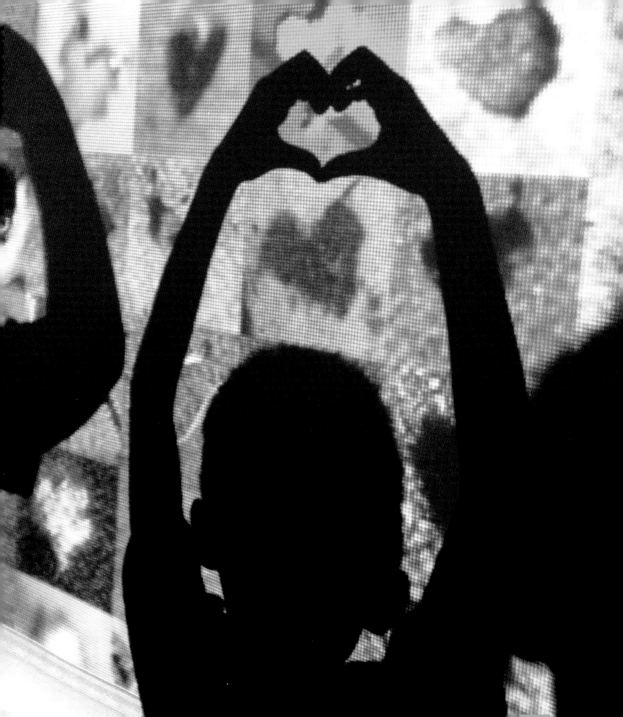

Share a heart

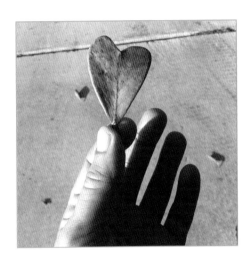

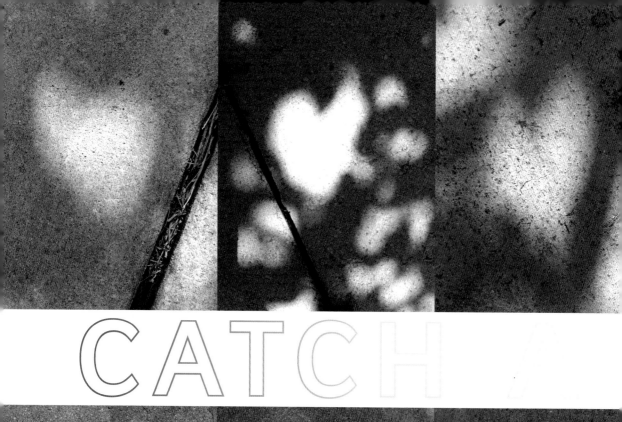

CATCH

HEART

Keep a heart

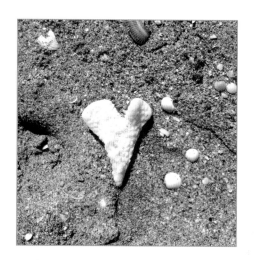

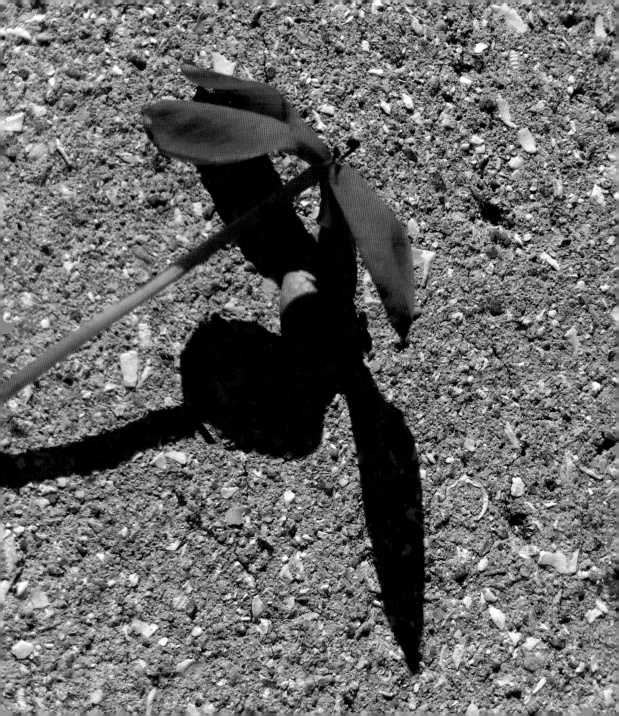

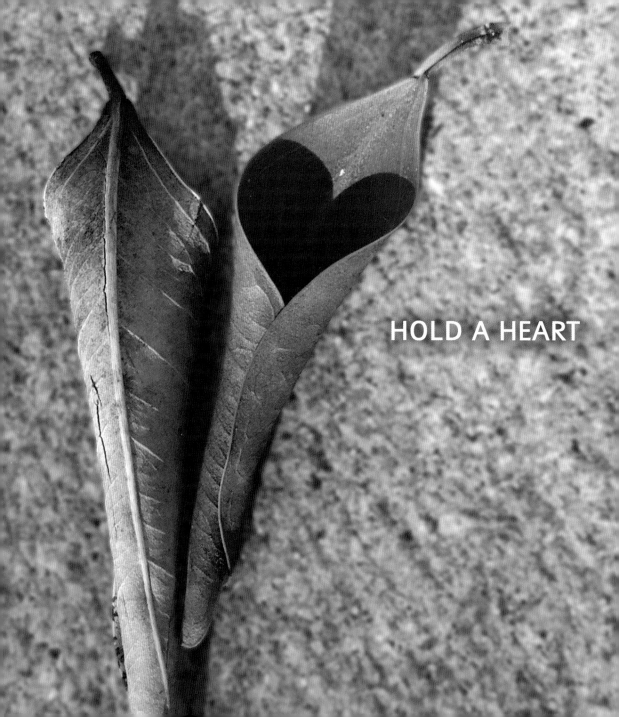

HOLD A HEART

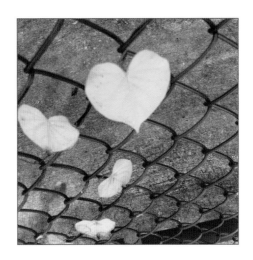

Free a heart

FIND A

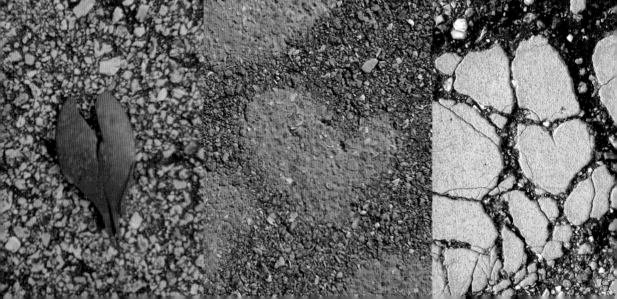

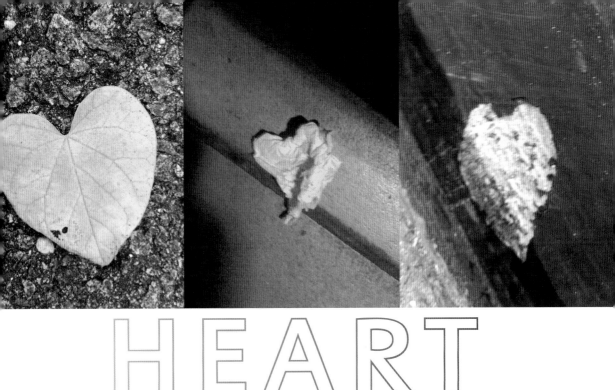

HEART

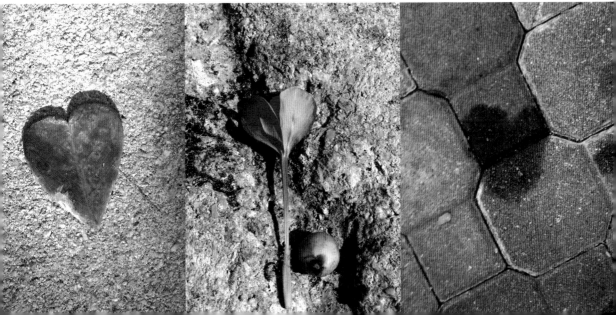

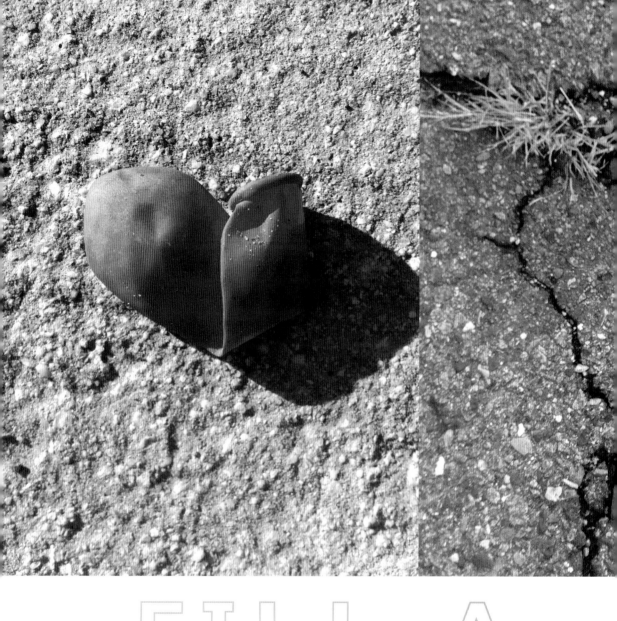

FILL A

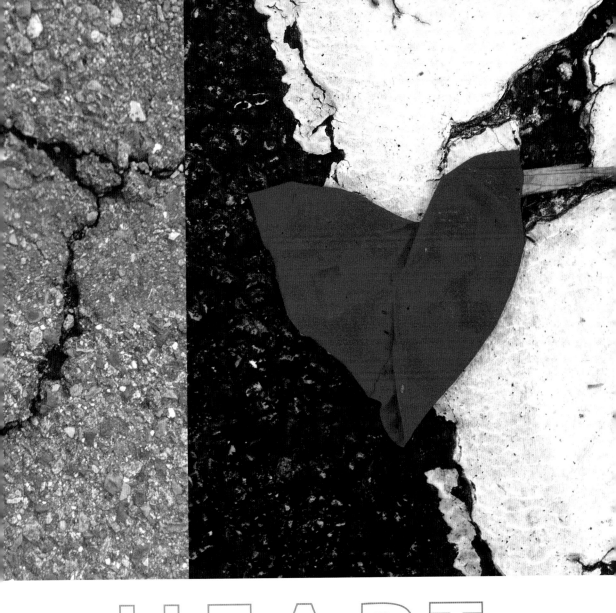

HEART

MOVE A HEART

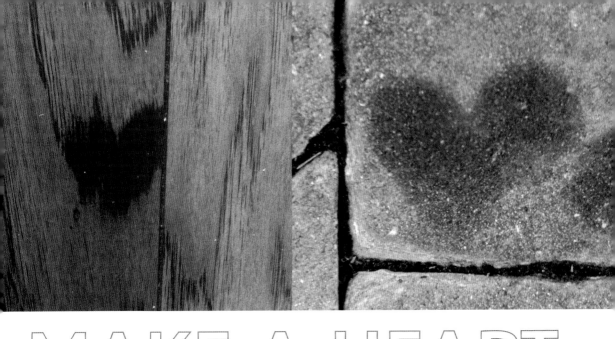

MAKE A HEART

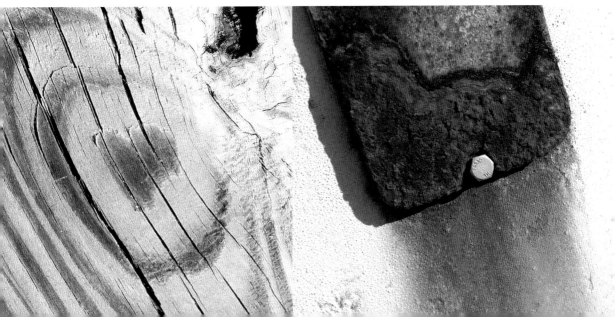

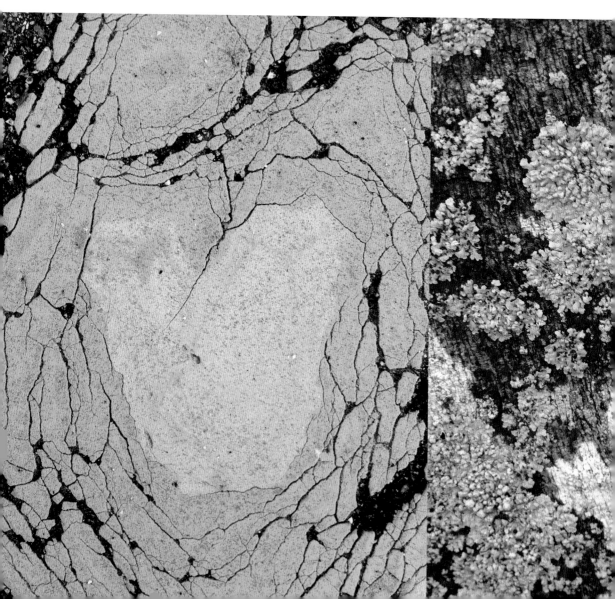

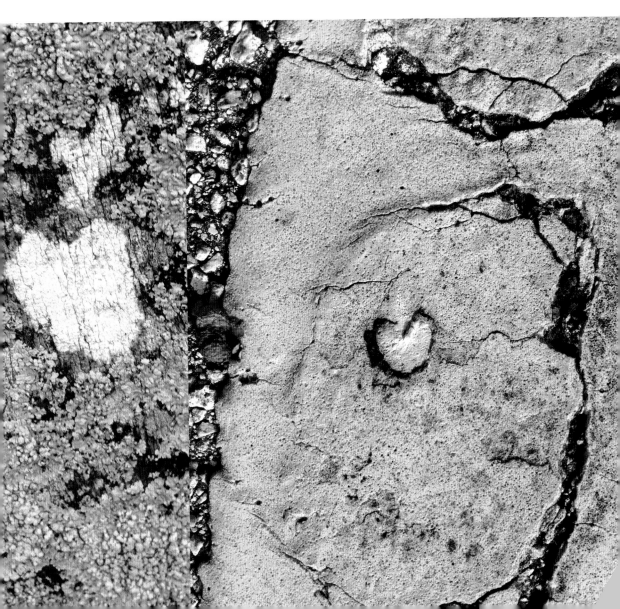

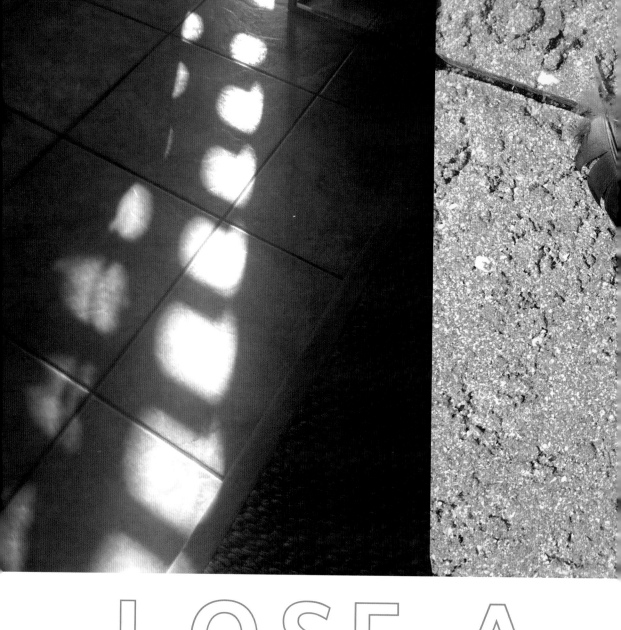

LOSE A

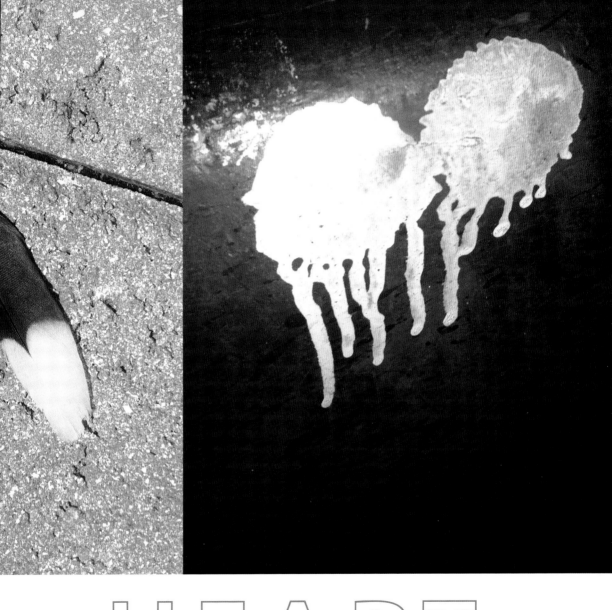

HEART

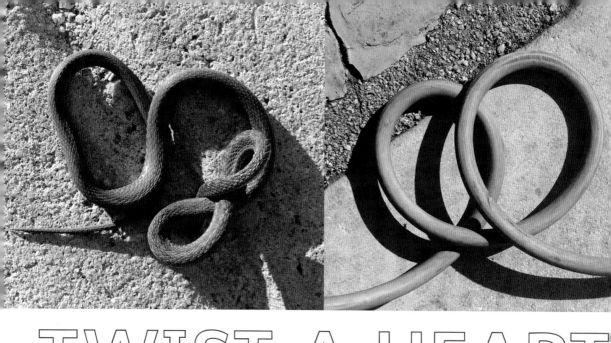

TWIST A HEART

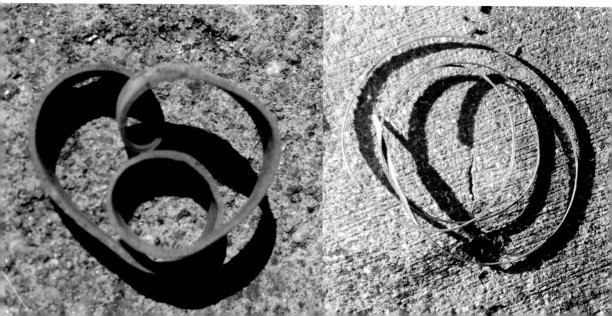

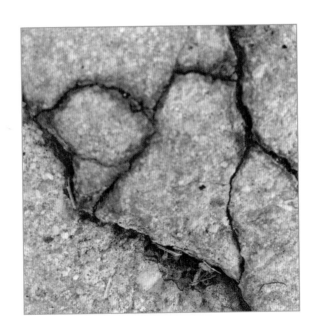

Break a heart

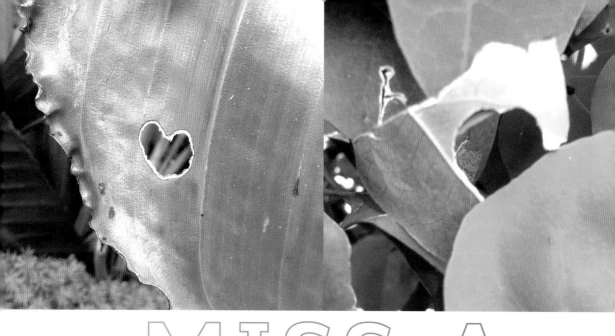

MISS A

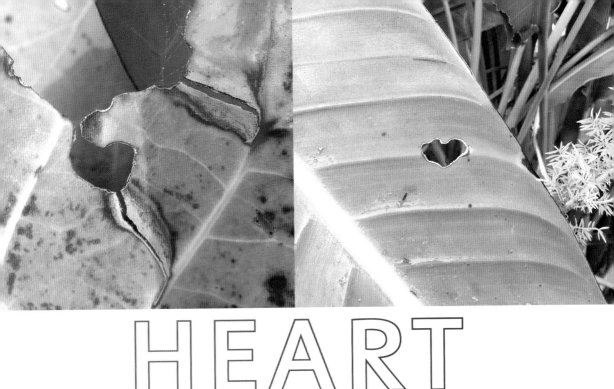

HEART

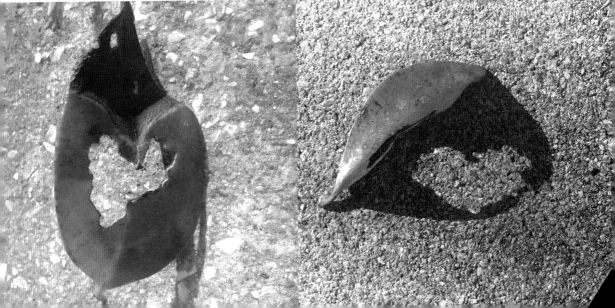

MEND A HEART

Warm a heart

TEND A

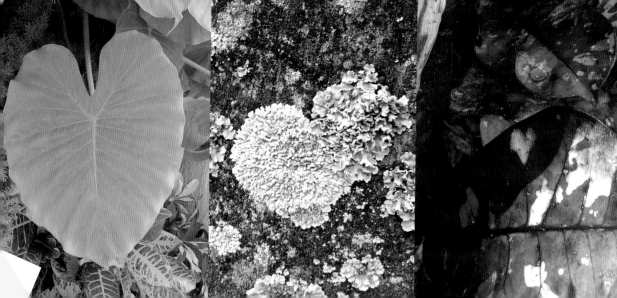

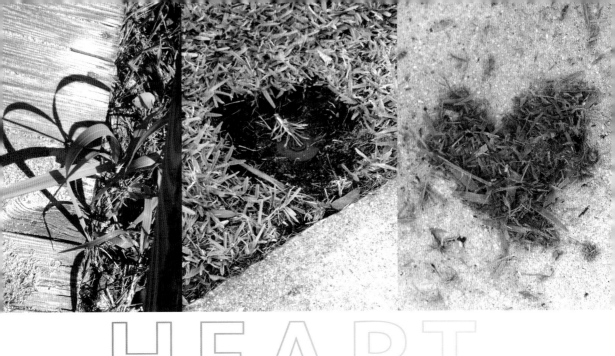

HEART

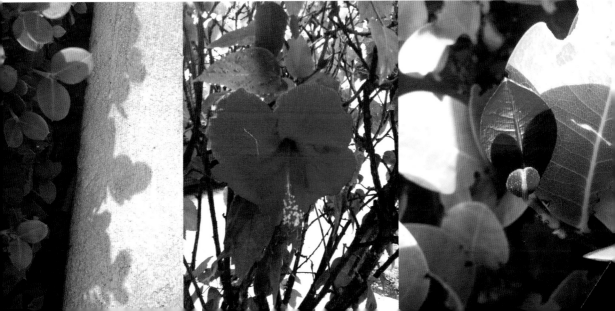

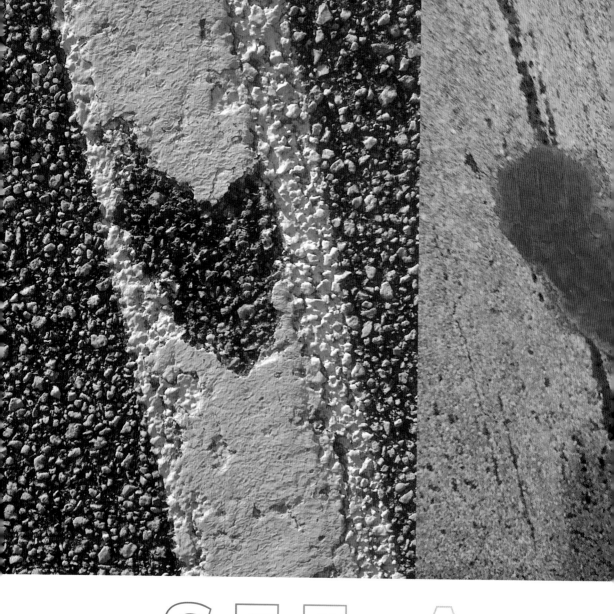

SEE A

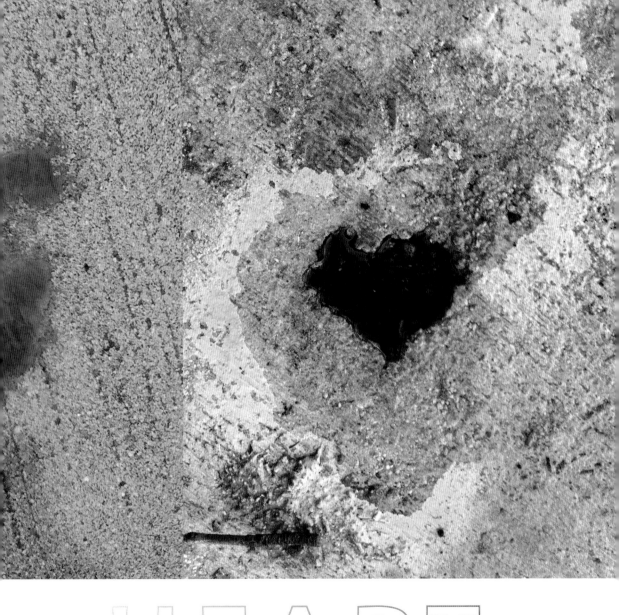

HEART

SHARE A

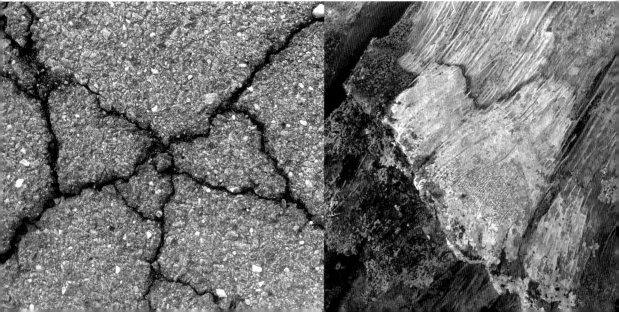

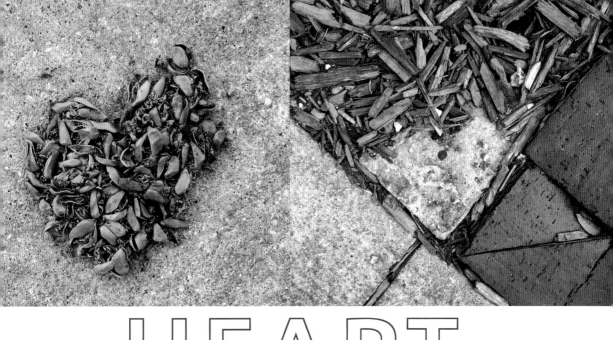

HEART

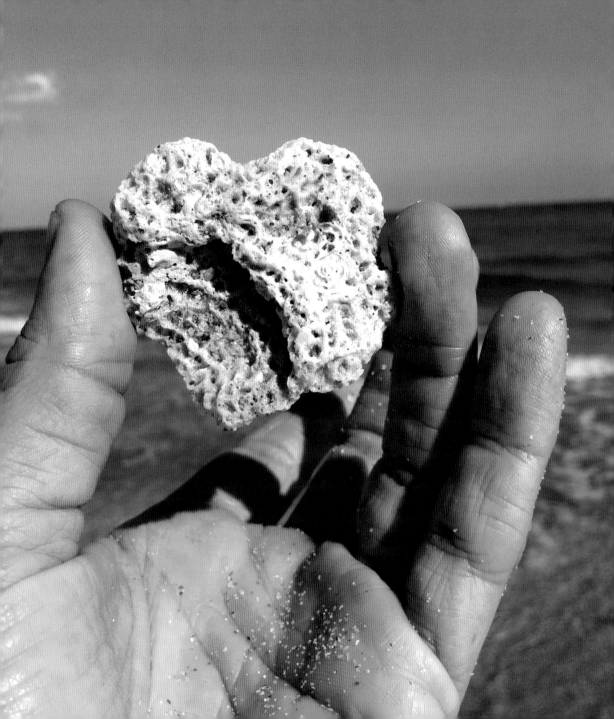

Touch a heart

CHANGE

A HEART

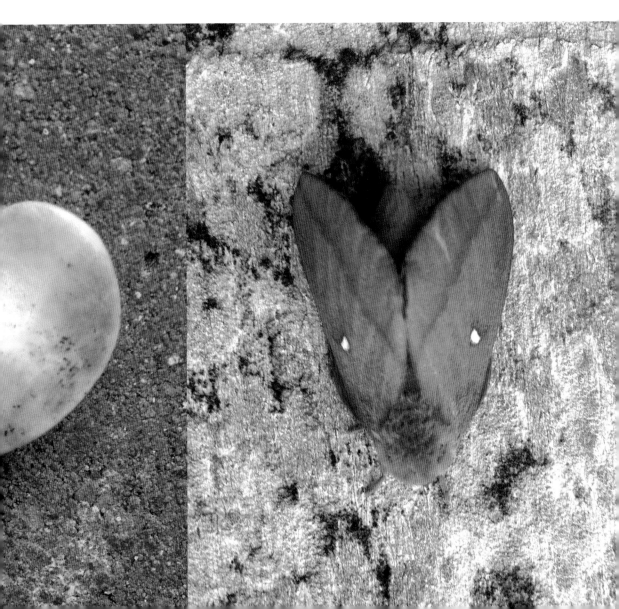

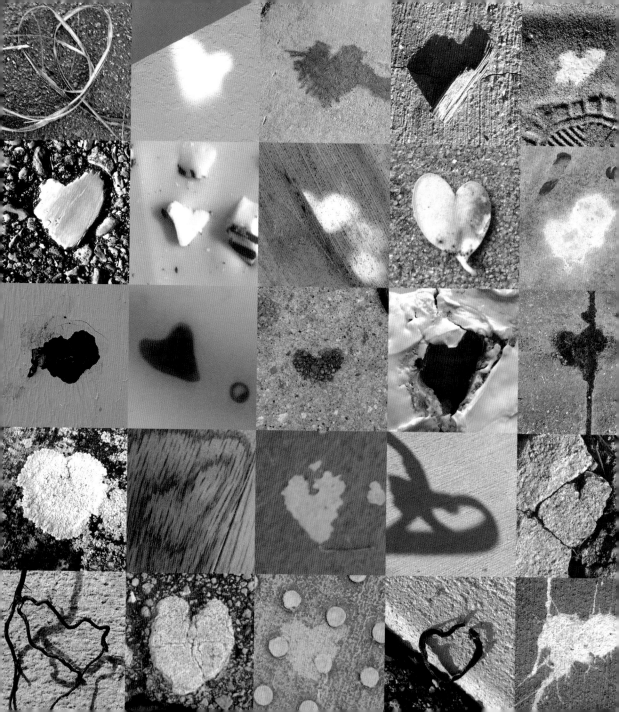

ERIC TELCHIN doesn't search for hearts; he just finds them. And, he's discovered the more hearts he shares, the more hearts he sees. He's met with more than a thousand elementary school students and has captured more than three thousand hearts with his phone's camera. He never composes or retouches his hearts. (He likes them just the way they are!)

Eric's heart artwork has been celebrated all over the world with features in magazines, blogs, art galleries, and even on prime-time television! He lives in South Florida and his favorite food is ice cream—chocolate, in case you were wondering.

A NOTE FROM ERIC:

I saw my first heart while I was hosting a friend's going-away party. It appeared in a puddle of melted ice cream. (Chocolate, of course.) Amazed, I took a picture of the heart-shaped spill with my phone's camera. (Can you find it on the opposite page?) When I started to notice more hearts, I realized that they were everywhere! In trees, on sidewalks—even in my breakfast. And, they came in all shapes, sizes, and colors. Once I captured a hundred hearts, I made a collage, printed copies, and framed them for my family and friends. Then *they* began to find hearts. I launched *www.BoySeesHearts.com* so I could share hearts with more people. I even upload a new heart every day! Now, people all over the world are starting to see and share hearts. And I know you will, too!

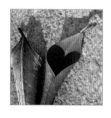

FOLDED LEAF SHADOW

Here's my favorite heart I've found so far. This folded leaf's heart-shaped shadow was so small (the size of a fingernail) I almost didn't see it! Maybe we pass by hearts all the time....

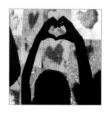

STUDENT PROJECTING HEART

When a second-grade student realized he could make a heart with his hands, he projected it onto the screen for everyone in his class to see. What a great way to share a heart!

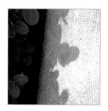

SIDEWALK SHADOW

I saw this leaf's shadow on a sunny day. Suddenly, a cloud covered the sun, and the heart vanished. The sun came out again, and the heart reappeared. Got it!

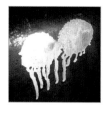

PAINT DRIPS

My friend Joanna and I hurried to her train. But I had to stop and photograph this heart I found along the way. The white paint drips on the street curb stopped at precisely the right moment to form a heart.

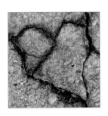

SIDEWALK CRACKS

I found this broken heart in sidewalk cracks. When I looked closer at the photograph afterward, I discovered a surprise: a second, smaller heart. See it?

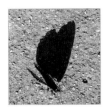

BUTTERFLY'S SHADOW

I was sure this monarch butterfly would fly away before I could capture its shadow. I tiptoed toward it. But shockingly, it didn't move. After I took the photo, it fluttered away.

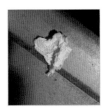

NAPKIN ON FLOOR

Someone must have meant to throw this napkin away. It was lying on the floor next to a garbage can. I love finding beauty in unexpected places.

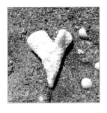

SHELL ON BEACH

My friend Kathy's mom gave her this shell. And she shared it with me. Seconds after I took this photo, a wave carried the heart into the ocean. I wonder who will find it next!

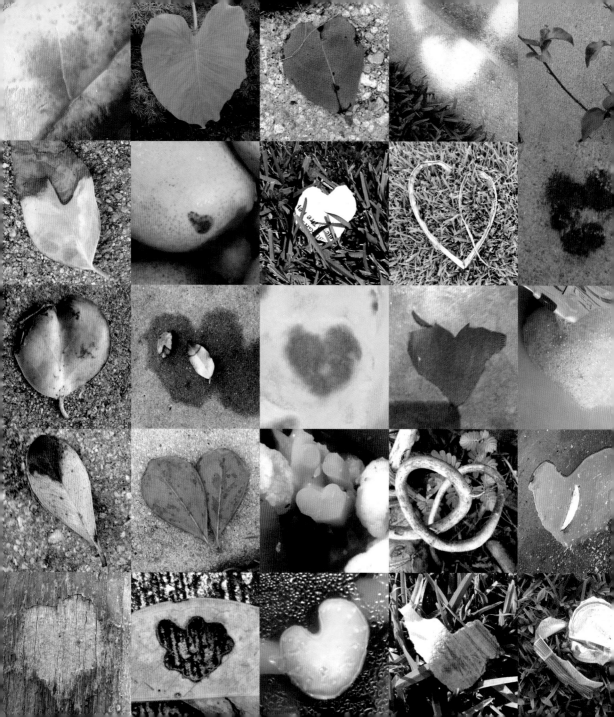